DIANE VON FURSTENBERG

THE WRAP

© 2004 Assouline Publishing for the present edition
601 West 26th Street, 18th floor
New York, NY 10001, USA
Tel.: 212 989-6810 Fax: 212 647-0005
www.assouline.com

First published by Editions Assouline, Paris, France.

Color separation: Gravor (Switzerland)
Printed in China

ISBN: 2 84323 524 3

ANDRÉ LEON TALLEY

DIANE VON FURSTENBERG

THE WRAP

ASSOULINE

first, there was Gabrielle Chanel, who created a feminine uniform—the soft cardigan jacket with four pockets—from an Austrian porter's jacket.

Then, there was Elsa Schiaparelli, the mother of modern fashion, who started her career with a single vision: a simple sweater with a *trompe-l'œil* bow at the neck.

After those two icons of the twentieth century came other great women designers: Madame Grès, Pauline Trigere, Claire McCardell, Anne Klein, Zandra Rhodes, Mary Quant, Sonia Rykiel.

And then came Diane von Furstenberg and her wrap dress.

Diane von Furstenberg is a name that resonates with every woman. It says comfort, accessibility, affordability, and empowerment. In her world, beauty and style begin with a sense of confidence—and individual style is based on freedom of choice.

Today, she continues to keep her iconoclastic collections—beauty,

accessories, and fashion—as James Brown would say, "on the good foot."

She is one of my very close friends. After meeting at a splashy party in the '70s, we went on to share so many great moments during that era—including marathon nights at Studio 54 and the Paris equivalent, Le Palace.

But it wasn't all about parties. Throughout her success, I have watched her go in and out of love, become a great mother, and now, a happy, devoted grandmother. Diane and her husband Barry Diller, one of the Hollywood super-moguls, have generously given back, with the Diller-von Furstenberg Foundation, a philanthropic organization that supports the arts and medical advancement.

h er story is the American dream: hard work, success, a passion for life, and love of her family, friends, and *métier*. With that sensuous, modern wrap dress, Diane gave the world the uniform of the '70s. The beat goes on.

"I will always be independent," said the eleven-year-old daughter of Lily Nahmias. Lily, who as a girl survived the hell of German Nazi concentration camps, passed on this strength to her daughter, which made her into the woman she is today. Diane von Furstenberg's work ethic, mixed with a strong European sense of sophistication, a deep commitment to family, friends, and her own self-invented empire, has kept her fires fueled since the very first day I met her.

After fourteen months in the camps and weighing only forty-nine pounds, Lily removed the numbers tattooed on her arm. With her reparation check from the German government, she bought herself a

sable coat to dispel the remembrances of suffering that lingered in her mind of walking in snow from camp to camp. In 1946, six months after her release from the Neustadt-Glewe camp, Lily Nahmias wed Leon Halfin, an electronics merchant, and started her family in Brussels. Diane, the princess of wrap, was born in 1947.

She arrived in New York in 1969, newly wed to the young Prince Egon von Furstenberg. Having designed a few little knit dresses at her friend Angelo Ferreti's factory in Italy, she packed them up and took them with her to the United States. While insecure and inexperienced on how to actually sell her ideas for these dresses, Diane tried to show them to people that she thought could help her.

I n January 1970, the dynamic, sensual Diane von Furstenberg tucked three little dresses into a suitcase and went off to see the high priestess of fashion herself, Diana Vreeland, *Vogue*'s legendary editor. Vreeland later recalled her first meeting with Diane: "She didn't come in with an idea. She came in with a package, with a product, with the whole thing worked out!"

My first encounter with Diane was a bit less direct. It was a cold November night, and I had been assigned to cover a big party at the Furstenbergs' Park Avenue apartment for *Women's Wear Daily*'s "Eye" column. I stood on the sidewalk in the bitter cold along with a photographer, who snapped the arrivals of Marisa Berenson, Dino de Laurentiis, Truman Capote, Barbara Walters, the super agent Sue Mengers, Jack Nicholson, Diana Vreeland, Andy Warhol, and his close Factory associates Fred Hughes and

Bob Colacello. I was brave enough to try and snatch a few quick-passing comments and throw a question here and there to create a story to run in the gossipy, society section of the paper.

Shortly after, in 1976, we were formally introduced at a New Year's party. On this night (also her 29th birthday) her then boyfriend, Barry Diller, gave her 29 loose diamonds in a Johnson & Johnson Band-Aid tin. I was, of course, impressed with the diamonds and with the sexy Diane, who has a voice that wraps itself around you like a cozy, warm cashmere muffler. From here on, I was not only asked to DVF's parties, I was invited for weekends at Cloudwalk, her eighteenth century farm in Connecticut.

a s Diane's idea of a cotton wrap dress in clever prints of leopards, snakes, panthers, or abstract art grew bigger, we became close friends. When I was sent off to Paris to become the European editor and bureau chief of *W* and *WWD*, for a brief, halcyon moment, Diane and I were bedding down, like boarding school buddies.

In those days, Diane would curl up in her white mink coat and a slip, her David Webb Lucite and diamond onyx bangles and Bulgari minaudière tossed on the side table, and conduct marathon phone calls to Barry Diller in Los Angeles. I would fall asleep in my turtleneck on top of the covers as we planned our next outing to the Palace or another Parisian nightlife hot spot. This was how I got to know Diane von Furstenberg.

"To be free and to be me" is DVF's mantra, and freedom is something that she's managed to find easily ever since she was young. As soon as she left her Belgian home as a young teenager for an English boarding school, the future princess of wrap took

off like a cheetah—one of her favorite prints—at high speed. At Stroud Court, near Oxford, Diane experienced country living for the first time, and discovered the healing powers of long walks. There, she began to dream of a new world order, an existence totally the opposite of the cozy yet limited life she had had with her parents in Belgium. This is also where the future designer got into swinging, hip style.

"I felt very insecure when I first arrived at the school," DVF revealed to me, one cool August day at Cloudwalk. "I discovered everything there, the most important thing, being free. Freedom to think, freedom to experience sensual passion, freedom to read, and freedom to dress."

from early on, Diane had a keen sense of self-awareness. Though she had close friendships with fashion icons like Marisa Berenson, she had already started her own signature look: soft, sensual fabrics, shoes that made her shapely legs look longer, and her special way of crossing her legs, with a slashed skirt or the hemline pushed or curled above her knees to reveal their sexy, feline quality.

In 1969, Diane married a prince (and the father of her future children) whose title dates from the Holy Roman Empire, Egon von Furstenberg. It was here that the story of the princess and the little wrap dress begins.

Born from a dolman sleeve top that she converted into a dress, the wrap was inspired by the simple shape of ancient Japanese kimonos. What was new in the 1970s was the wash-and-wear, drip dry dress in bold, modern prints—the antidote to high fashion.

With this single innovation, Diane liberated an entire generation of women from the limited sartorial options of the time. As women began to abandon kitchen chores and domesticity to hit the workplace in droves, they were forced to wear pantsuits or risk being shackled by the romantic idea of dressing like gypsies or Indian princesses. The timing was right for a new, liberated fashion for women.

The timing was also right for the raven-haired European with an accent right out of Central Casting, and legs as sexy as Marlene Dietrich's, with a dress that was all about fit, comfort, ease, and practicality.

The first wrap dress arrived in 1973—and swiftly grew into a phenomenon. Because the dress was so easy to wear—no zippers, no buttons, no fuss at all—women easily slipped them on for work and continued wearing them into the evening with jewelry and heels. Both extremely sexy and extremely practical, the wrap dress became an icon in the culture of women's liberation. From housewives to major celebrities (Cheryl Tiegs and Candice Bergen) to political wives, activists, and even feminists like Gloria Steinem, the dress was everywhere.

While Diane had been successfully designing dresses for three years prior, it was not until that little dress was created that the cultural phenomenon—which still resonates today—was born. And according to Diane, the idea for the dress came to her very simply and quite practically—after seeing Julie Nixon Eisenhower wearing one of her wrap tops and skirts together on a television appearance. Diane thought: "Why not combine the two pieces to make a dress?"

Diane traveled the country, making store appearances and meeting the women who bought her dresses. She was then selling throughout the United States, in stores such as Bloomingdales and Lord & Taylor. She knew her customer and knew her dresses were about those women—transcending age and demographic. The dress was made to make every woman feel seductive and strong—like her.

by 1976, DVF was shipping 25,000 wrap dresses a week to stores across the U.S.A. It was right at this time that my great friend, Carrie Donovan (an editor who helped steer the careers of her friends, including Halston and Calvin Klein, through the roughest seas of early existence) told *The Wall Street Journal,* "There was a void in the market.... There's something universally appealing about her clothes. There's nothing revolutionary about her, nothing highly original in her designs, just this combination of a very good fit for all kinds of women, good fabric, and she came in with a good price. She's also a worker, like nobody's business."

A few months after *The Wall Street Journal* hit the stands, in March of 1976, Diane was featured on the cover of *Newsweek*—the pretty European princess with the little wrap dress was being taken very seriously. The article proclaimed that "at 29, dress designer and haute hustler Diane von Furstenberg has become the most marketable female in fashion since Coco Chanel." Karl Lagerfeld was quoted as saying: "Her dresses respond to the needs of the American woman.... Diane has logic and common sense."

Building on the success of the dress, Diane von Furstenberg's

brand became an empire of perfume and bath products, sunglasses, accessories, jewelry, luggage, home furnishings, fabrics, and even shoes.

But eventually the invisible blight—overexposure—had sunk into every fiber of the brand.

After numerous episodes of restructuring the business, buying back huge chunks of her name from licensees, Diane left New York City. For over a decade, she spent time concentrating on her family, traveling, writing several books, and eventually pioneering into the world of home shopping.

t hen, in 1997, Diane von Furstenberg saw a new generation in hot pursuit of the classic wrap. A generation of young women, including her daughter Tatiana and daughter-in-law Alexandra, was beginning to discover the '70s wrap in vintage boutiques. Suddenly they experienced the joy of the fit, the instant cling and curvaceousness the dresses gave to the silhouette.

"It was one of the biggest surprises to me," Diane told me, when suddenly downtown girls were wearing her vintage dresses with black Doc Marten boots and uptown girls like Brooke de Ocampo wore them with Manolo Blahnik sling-back stilettos.

So, Diane re-launched her company, creating an atelier at the edges of the meatpacking district in New York City—based on the same simple philosophy of her '70s phenomenon: the wrap dress. Her modern "wrap star" status still fills the needs of working women, who have the confidence to be powerful in the workplace but never forget for a second their femininity. And today the

company, growing ever so rapidly, has expanded to include a full line of sportswear, dresses, lingerie, sunglasses, makeup—with a line of accessories coming soon. With experience under her belt, Diane has emerged more powerful and salient than even before!

everything with Diane owes its success to timing, hard work, and the right positioning of product. The continued success of the wrap dress, in a panoply of variations in each collection, can be seen in department stores and specialty stores throughout the world (over 650 locations), including the free-standing DVF boutiques located in NYC's meatpacking district; Coral Gables, Florida; London's Notting Hill; and on the right bank in Paris.

From wrap princess at the age of 29, she is now the wrap empress. Her strength of character, success, and longevity in the fickle fashion world are as solid as steel cords. In this remarkable story of the rise to riches and success, Diane has, with great style, turned one sexy, go-everywhere jersey dress that cost a mere seventy-five dollars at the peak of its success in 1976, into an empire that expresses everything a design brand would want. Diane, like the famous mythological heroine, Diana the huntress, is a free-spirited woman who has lived up to all the expectations she set during her early teen years in Europe. At the same time, she has never forgotten the importance of home, and nurtures her life with love.

In her spring show for 2004, what struck me as a perfect symbol of her whole ethos—as a designer, as a woman empowered early on in life to become an individual who could, in the course of her life, make a difference, not only for herself but for her family and for women who wear and love her clothes—was a revisited, modern

version of one of her dresses paired with a huge white straw platter of a hat she sent out on the runway. The hat spelled out the word LOVE in Boldini Bold print. It was a new remix of her own glamorous, jet set life of the '70s when she and Marisa Berenson would sit it out in popular watering holes on the French Riviera, or in Rome, on the via dei Condotti, or in Capri, looking ever so chic.

t he most important thing about Diane von Furstenberg is that she has maintained a firm grip on her values. Even during her twenties, when she saw her visage beaming down from countless magazine covers and portraits painted by the likes of Andy Warhol, she was a daughter who stayed close to home, and a mother, who always put her family before her business. When her mother, Lily, after years of putting the concentration camps behind her, wanted to mourn those memories with the opening of Holocaust Museum in Washington, D.C., Diane took her entire family there during the opening weeks.

Not bad for a designer who never went to design school or even learned to sew. Diane can be proud of her achievements: she invented a modern fashion classic, the wrap dress. Not bad at all, for this young girl who told her mother at eleven that she would be independent. Not bad for a big dreamer from Brussels, who, armed with precious memories from her youth and the strong family values that her mother's victory instilled in her, turned her dreams into an international brand. There is no stopping her!

DIANE von FURSTENBERG

OFFICE OF THE
Editor-in-Chief

VOGUE

689-590

THE CONDÉ NAST PUBLICATIONS INC.
420 LEXINGTON AVENUE, NEW YORK, N. Y. 10017

April 9, 1970

Diane:

I think your clothes are absolutely smashing.

I think the fabrics, the prints, the cut are
all great. This is what we need. We hope to
do something very nice for you.

Also, do you need any help with stores?

If there is anything you want us to do, please
don't hesitate to call.

~~Very sincerely yours,~~

much love!
Congratulations —

Diana Vreeland

Diana

Princess Egon Furstenberg
1155 Park Avenue
New York, New York

Newsweek

March 22, 1976 / 75 cents

Rags & Riches

Dress
Designer
Diane von
Fürstenberg

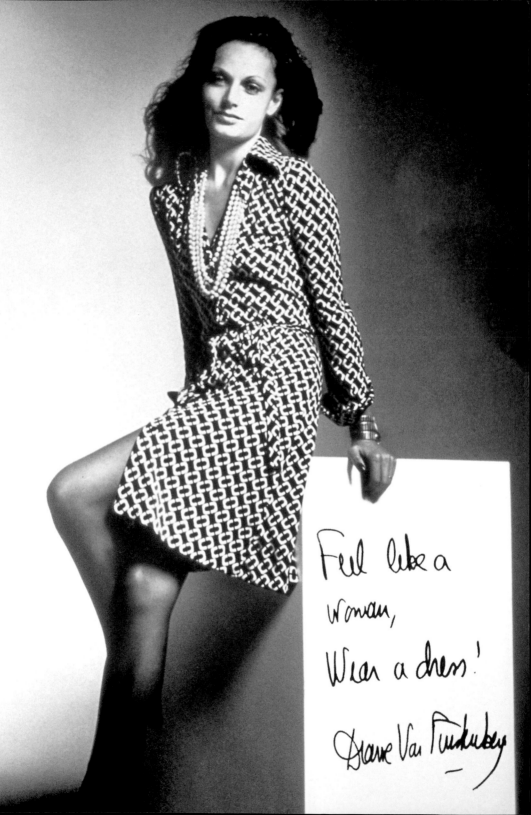

Feel like a
woman,
Wear a dress!

Diane Von Furstenberg

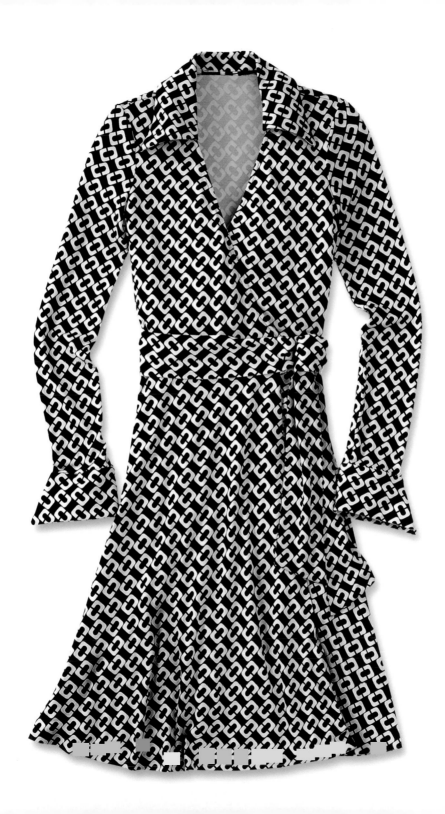

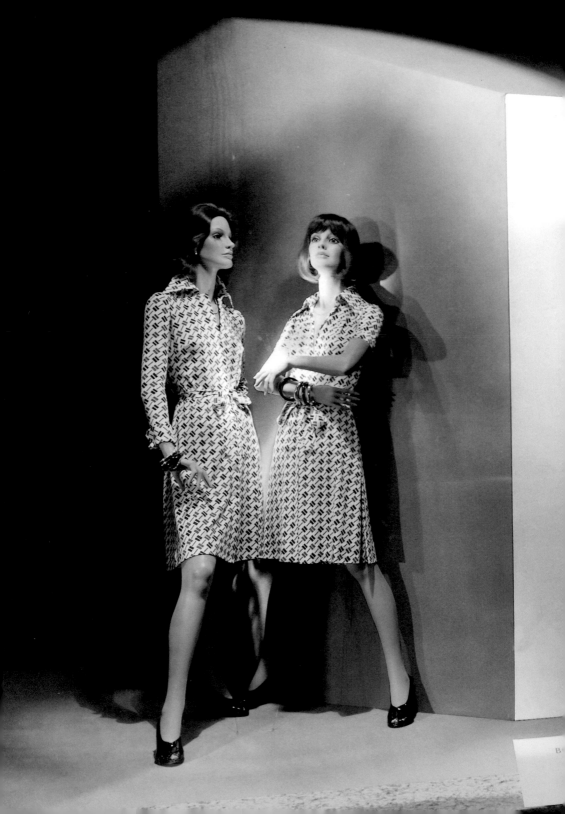

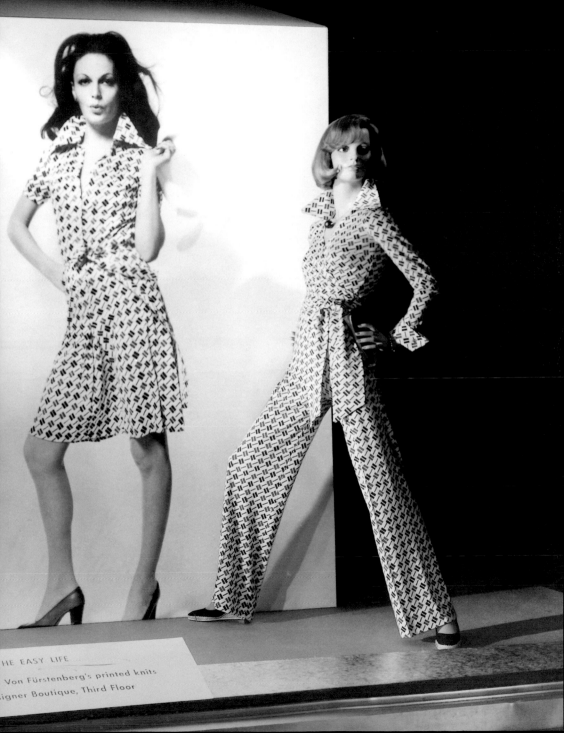

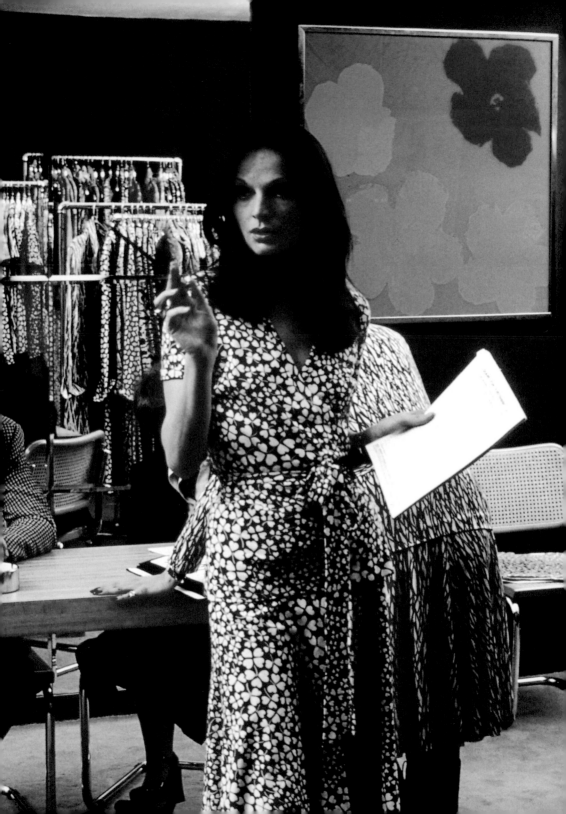

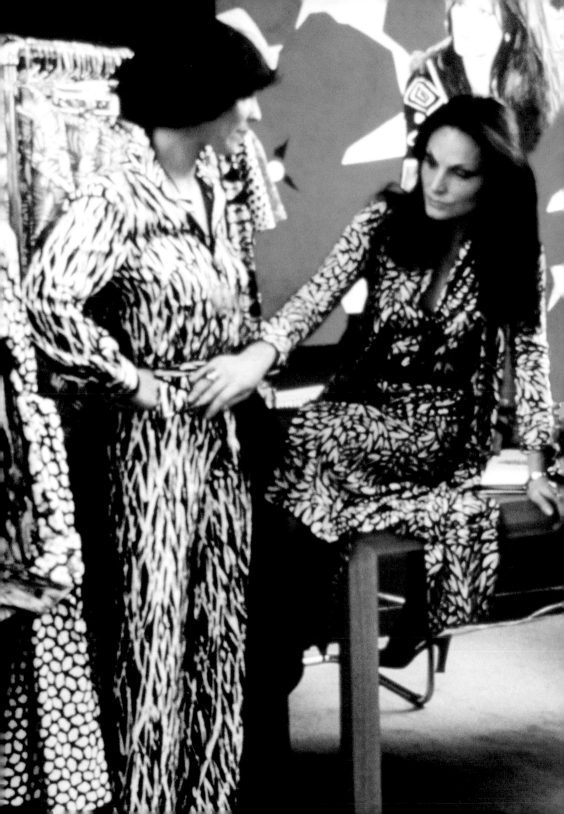

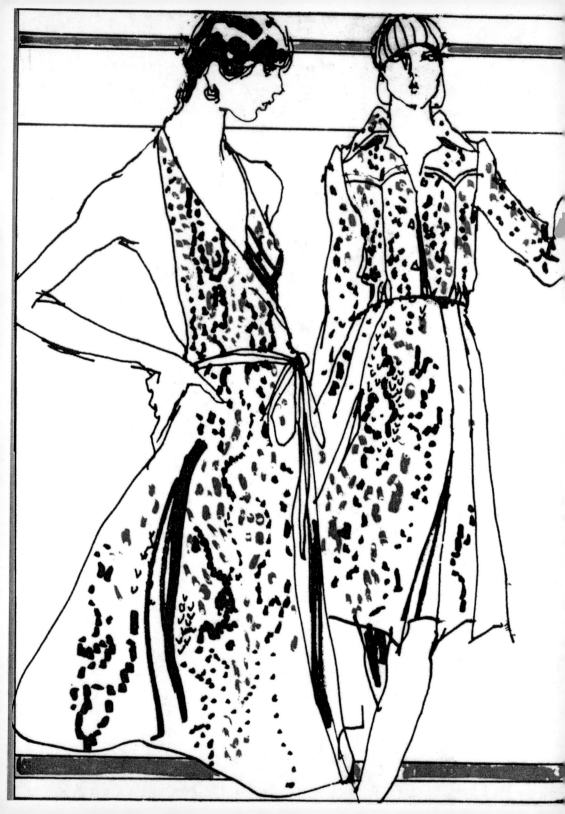

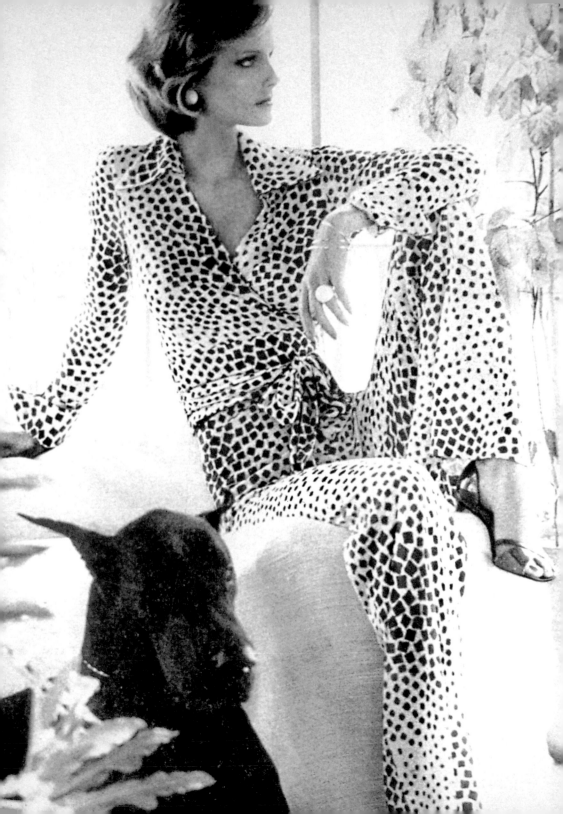

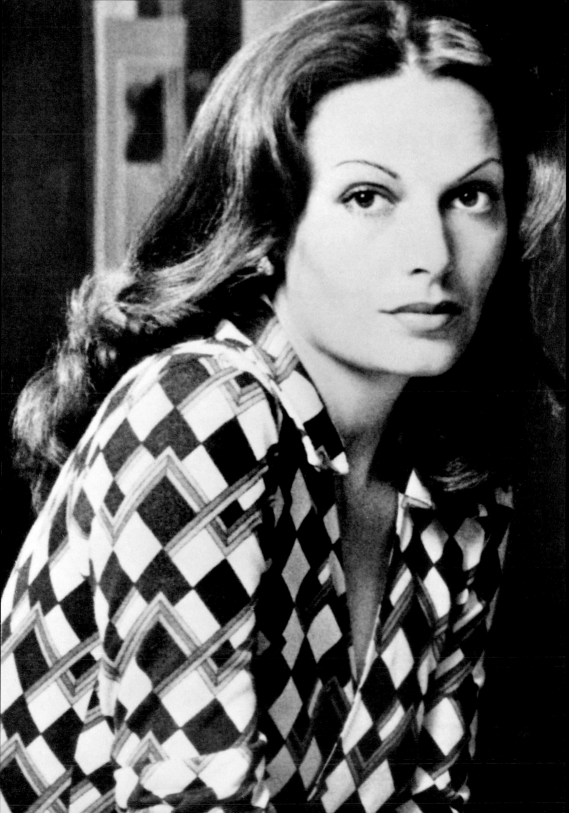

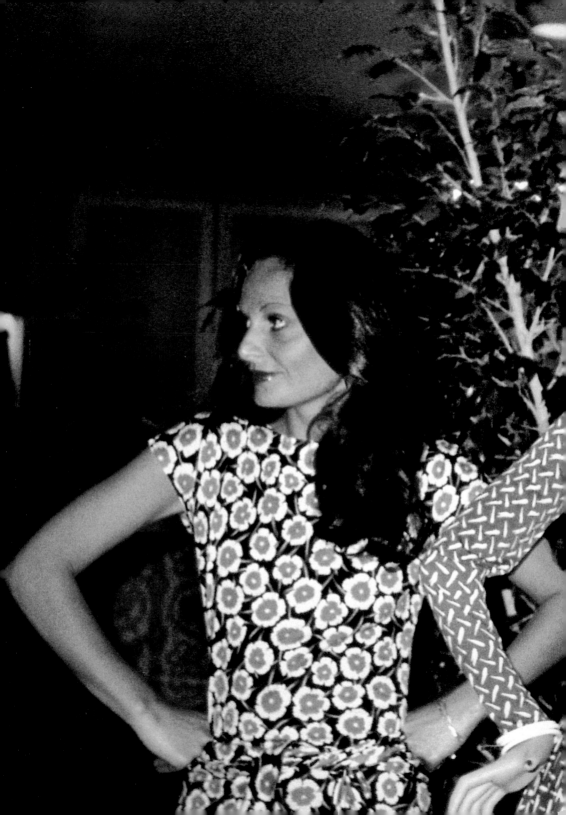

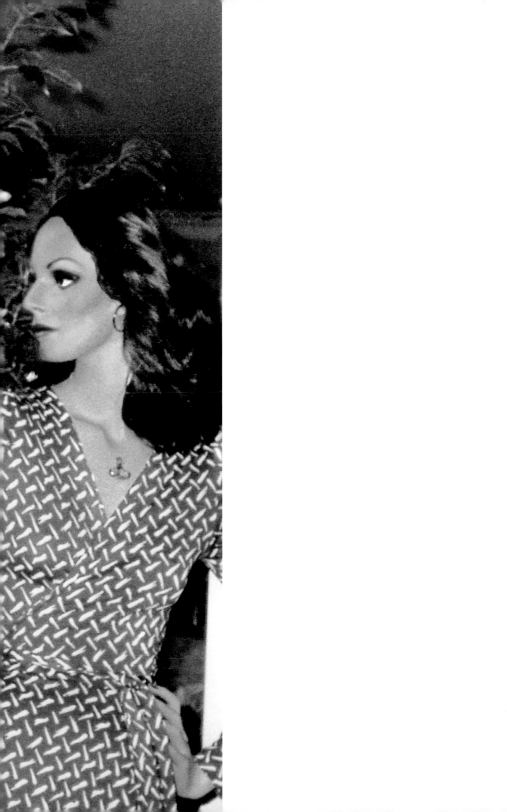

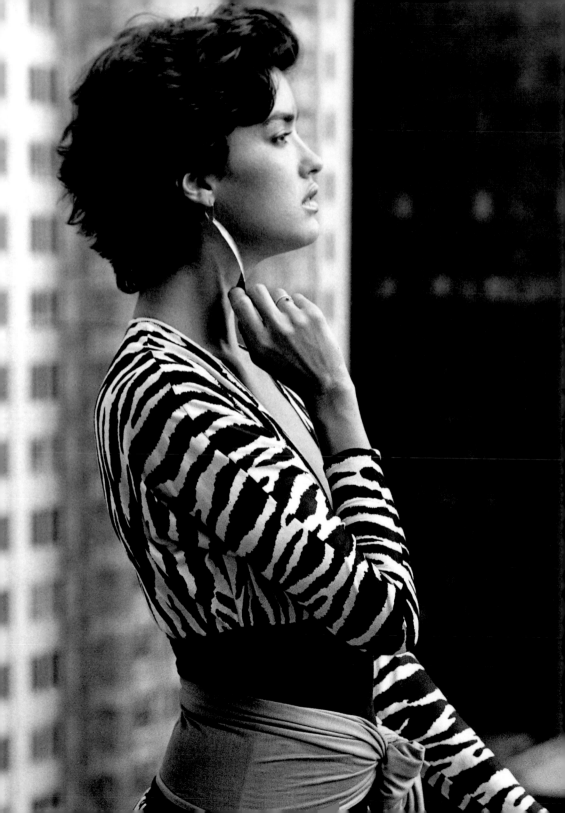

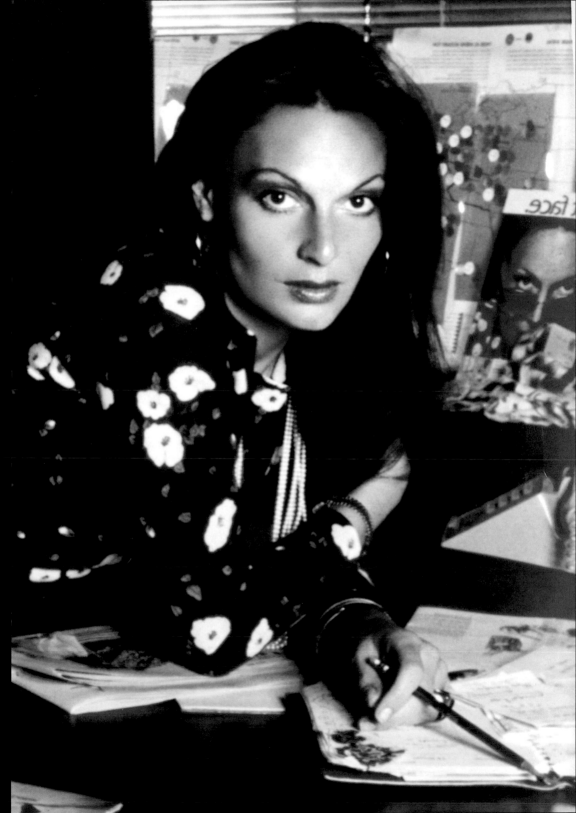

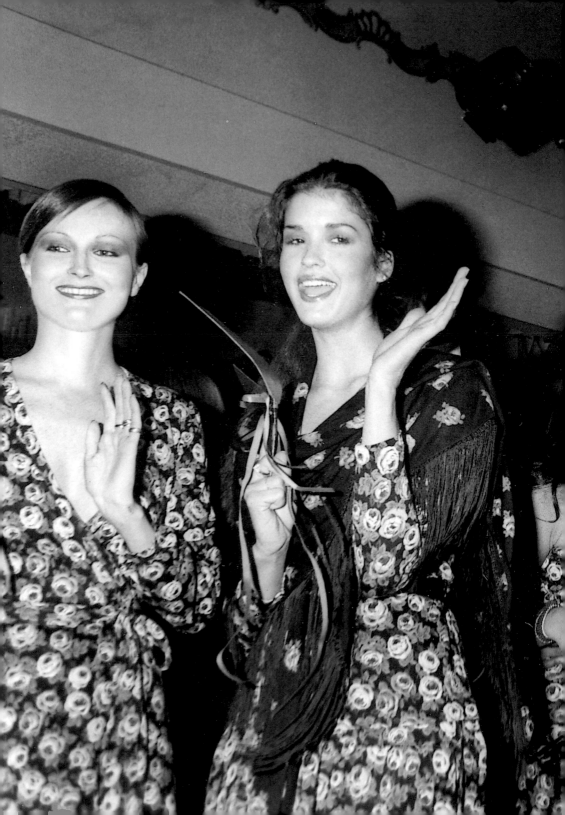

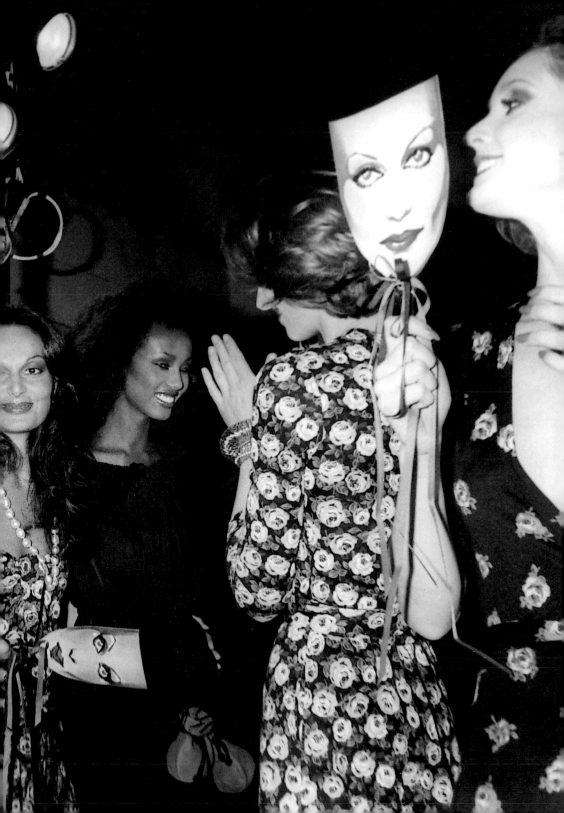

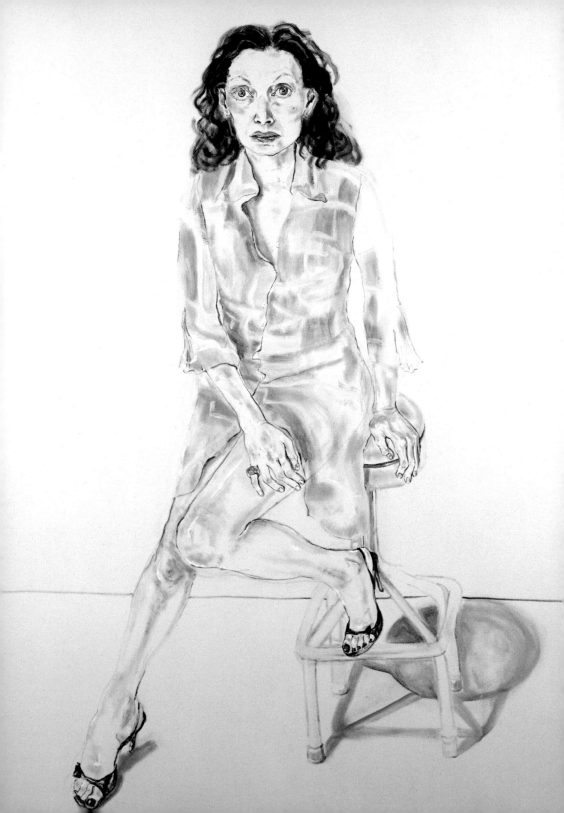

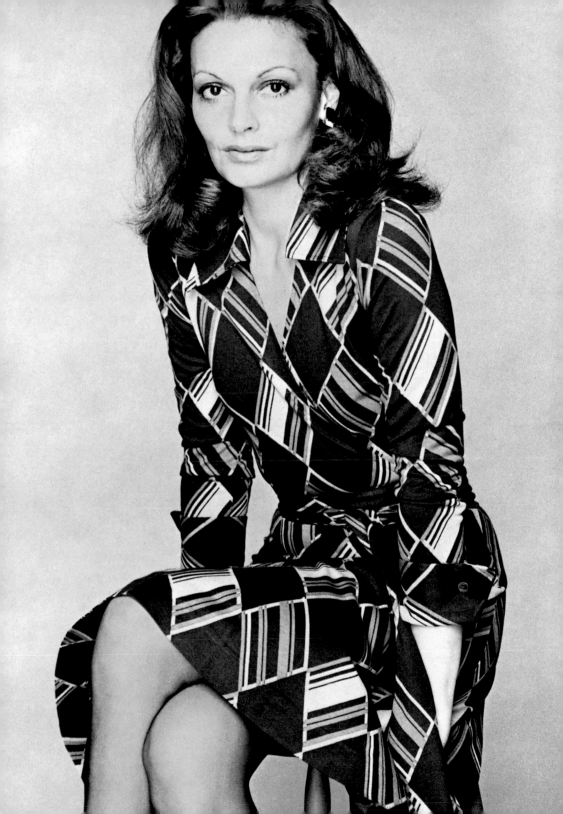

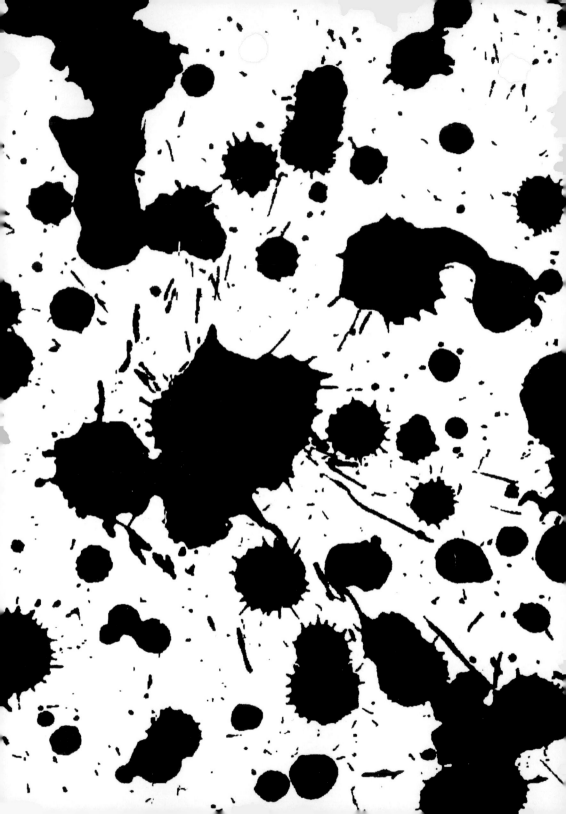

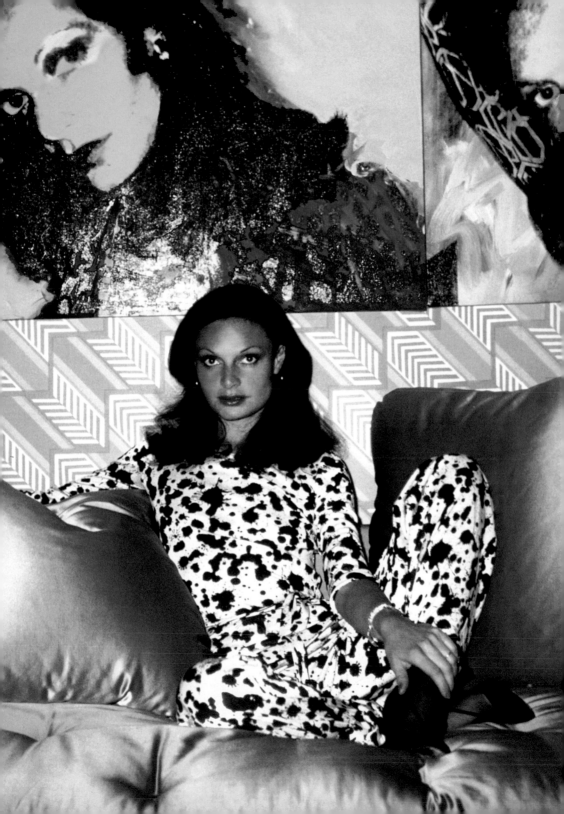

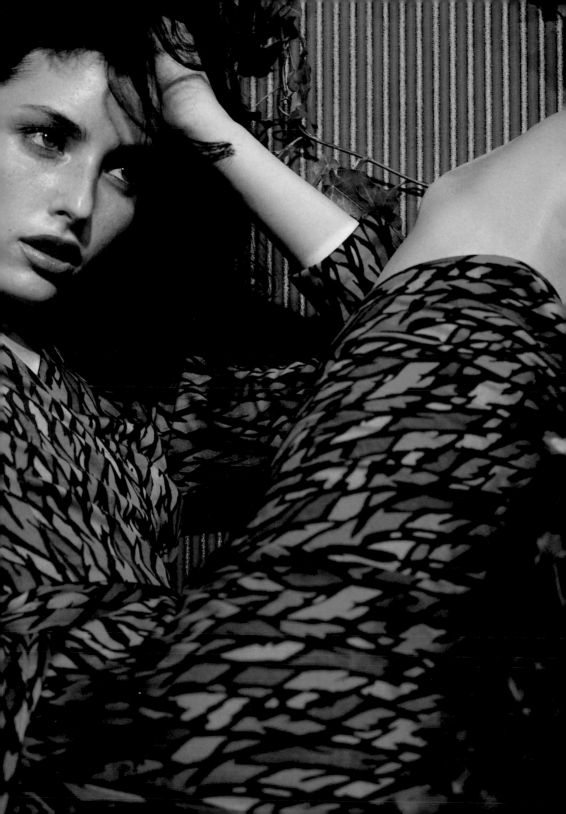

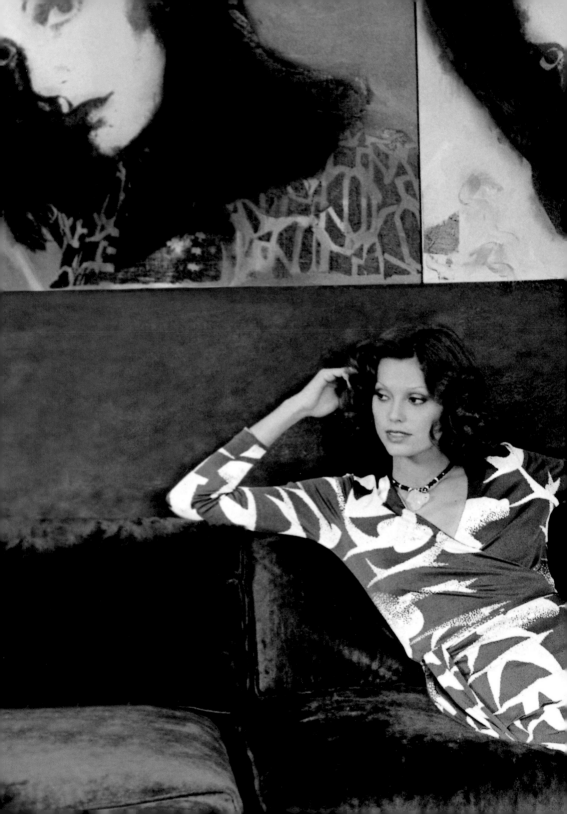

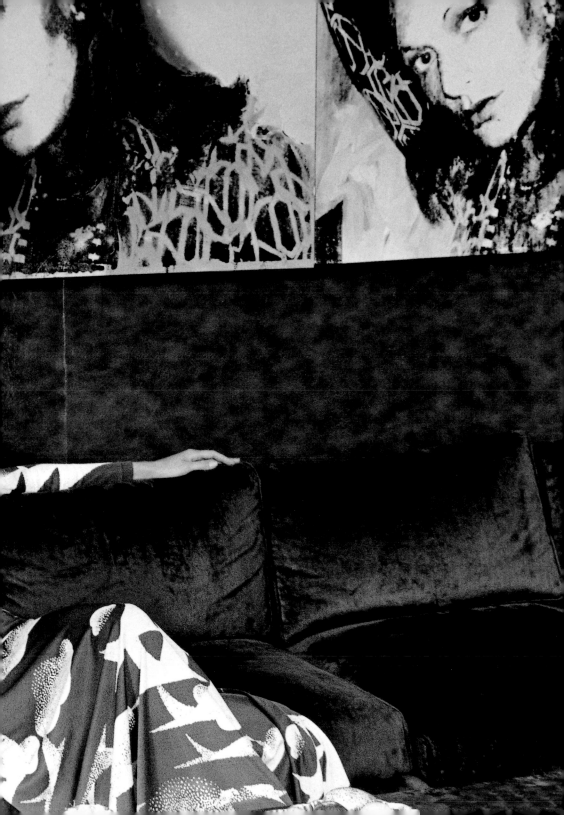

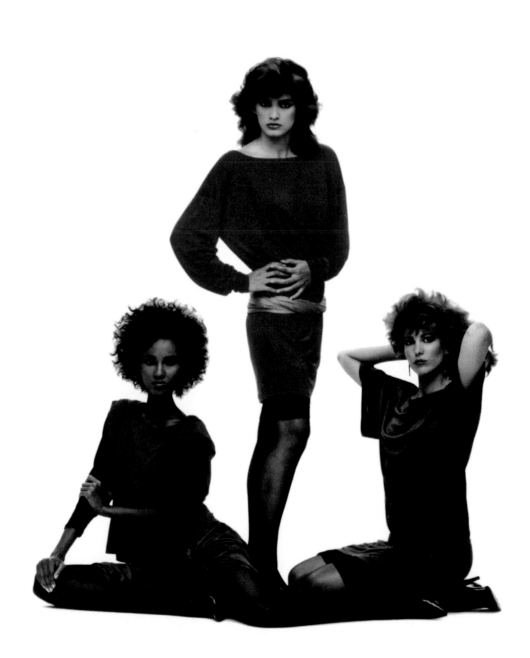

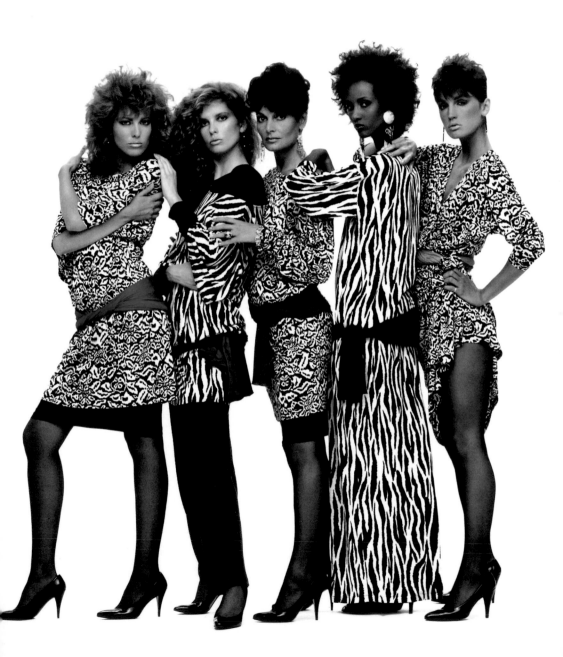

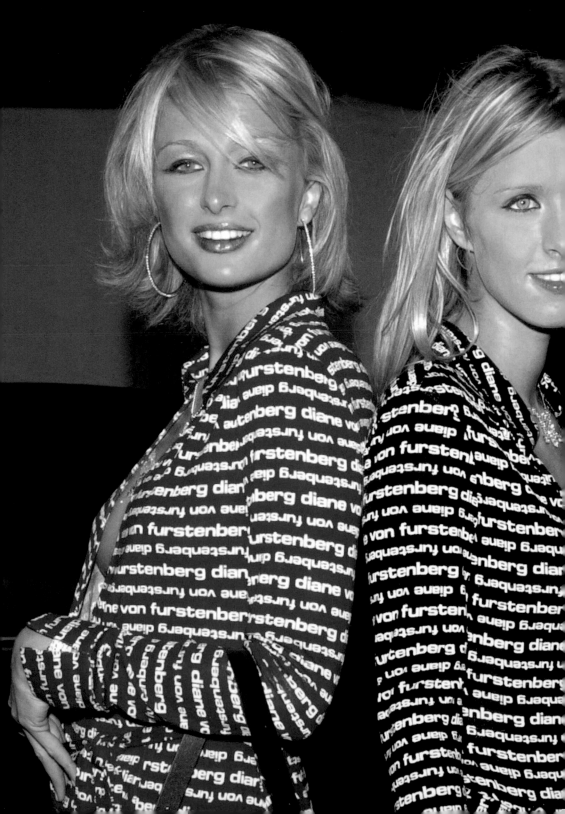

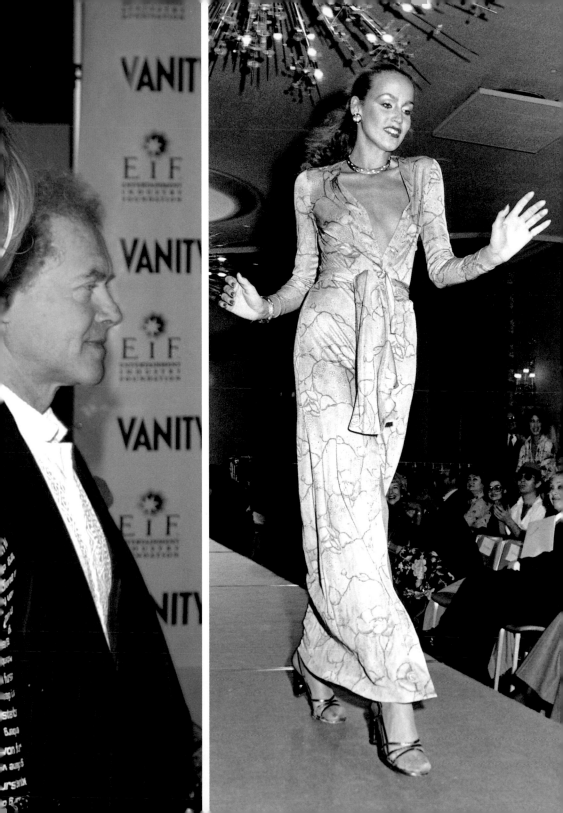

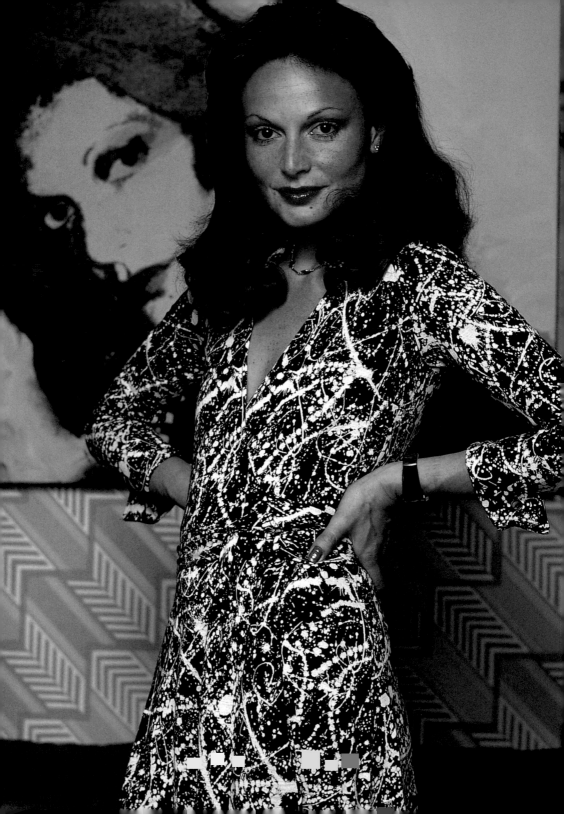

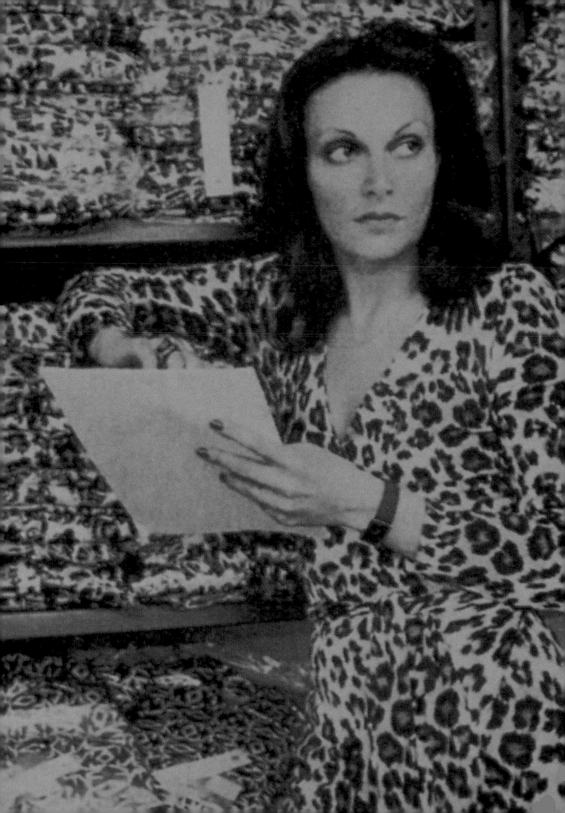

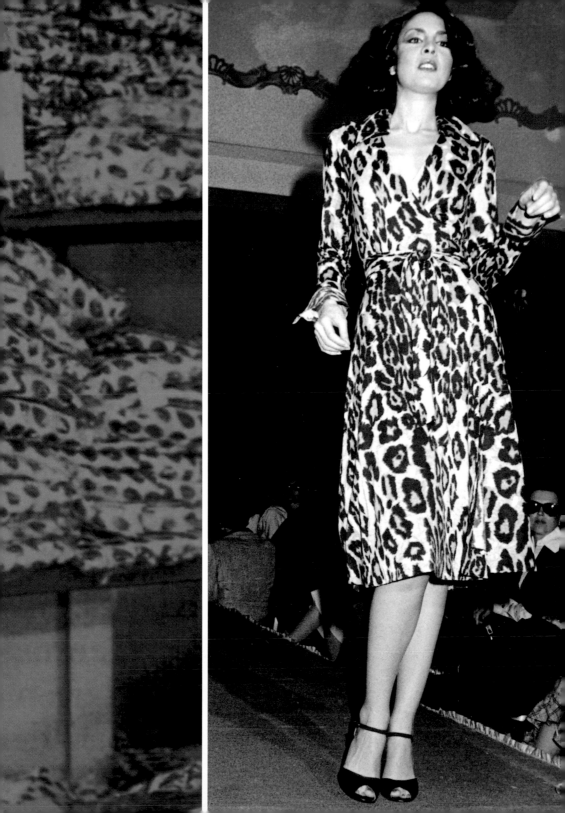

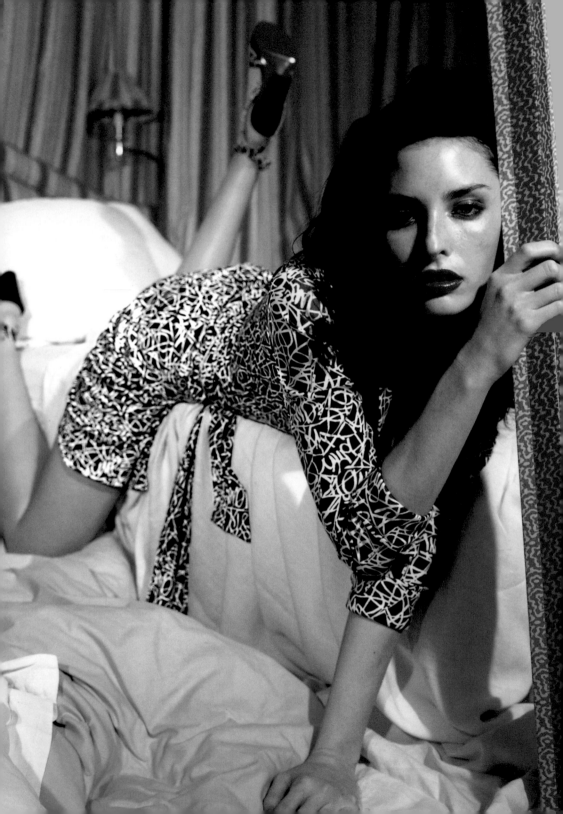

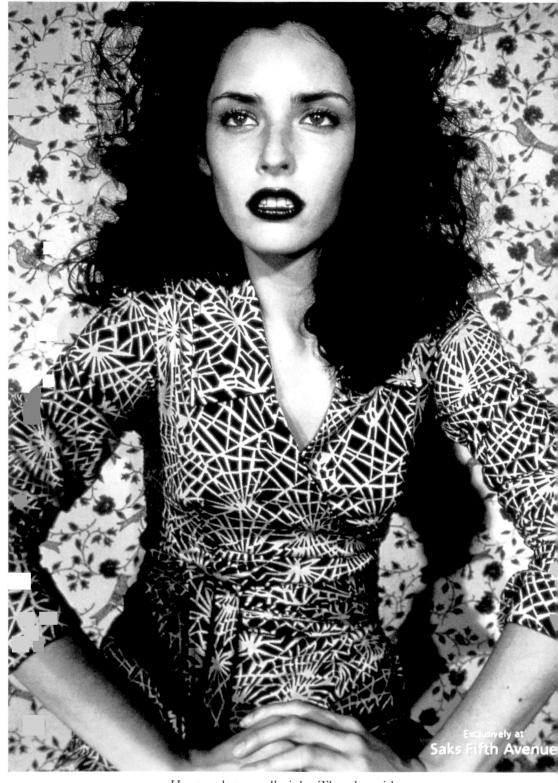

He stared at me all night. Then he said…

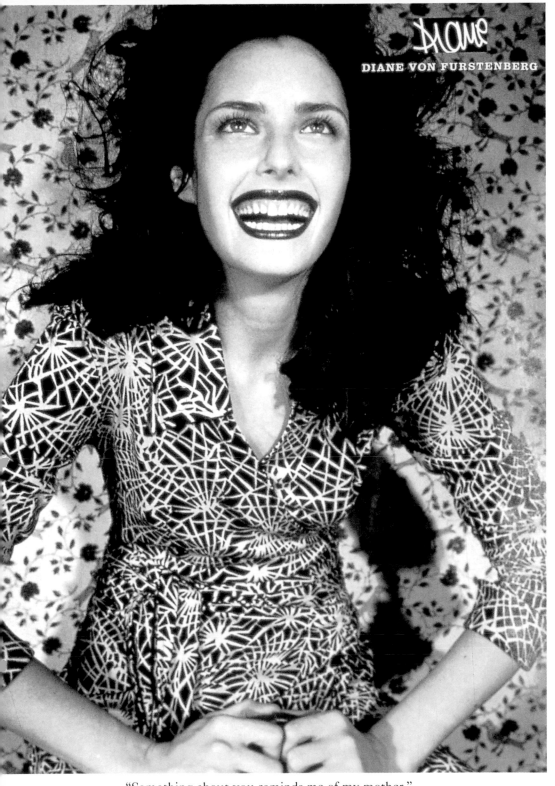

"Something about you reminds me of my mother."

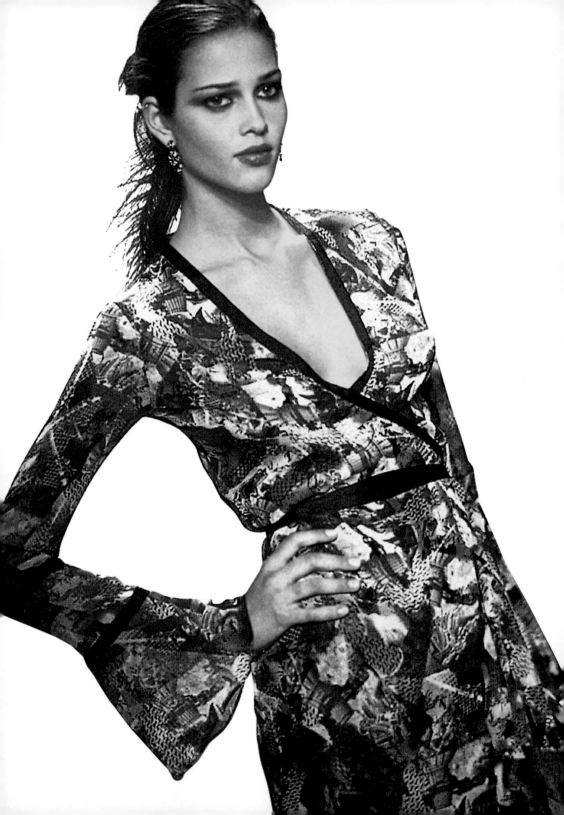

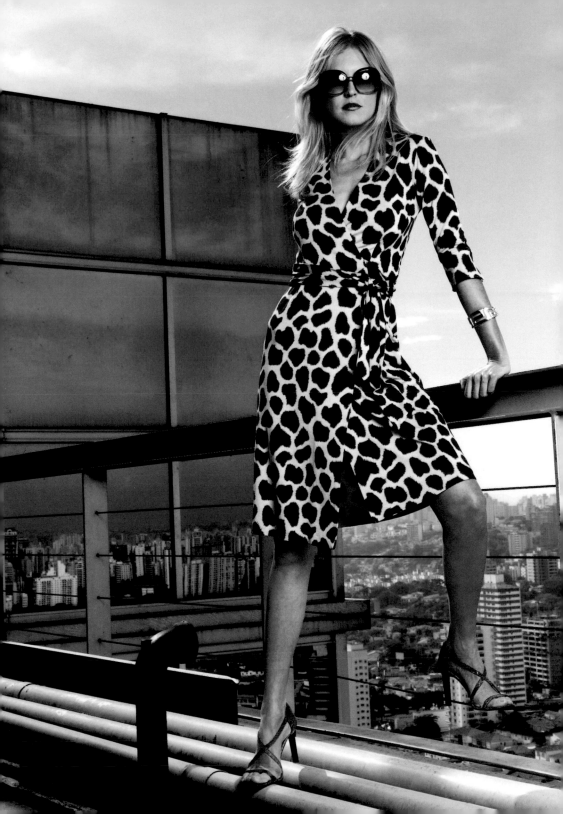

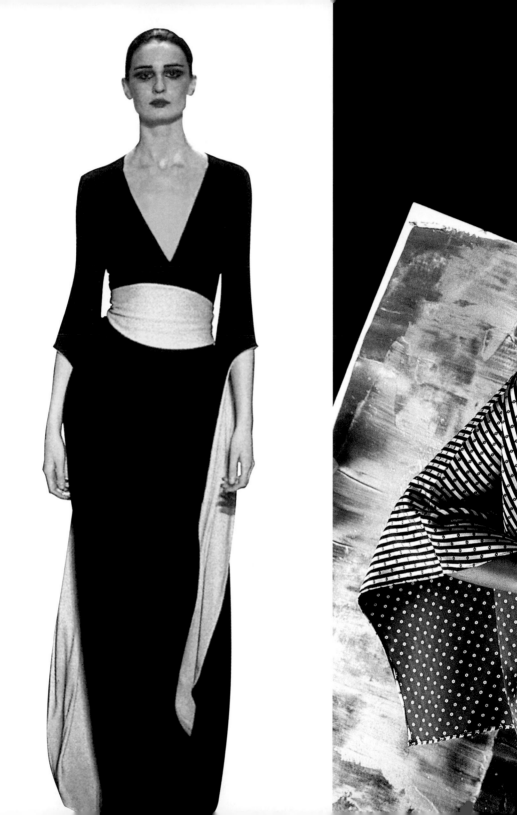

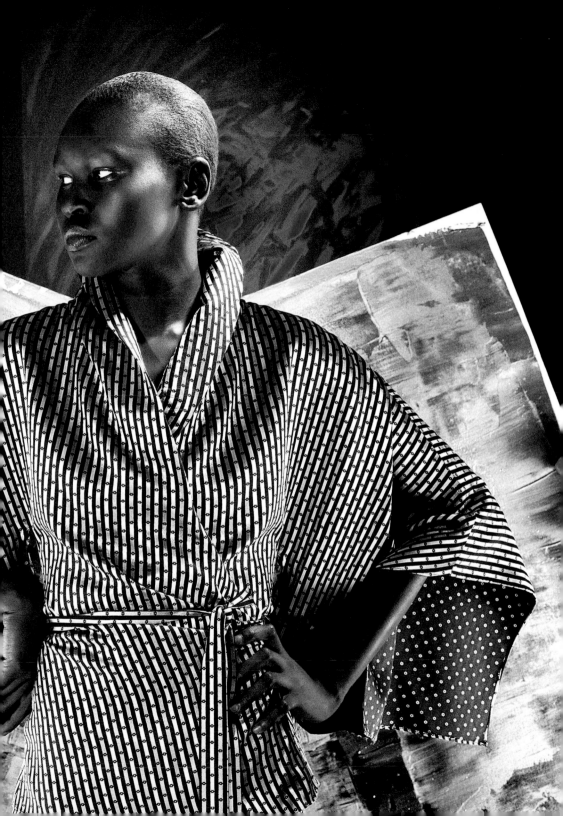

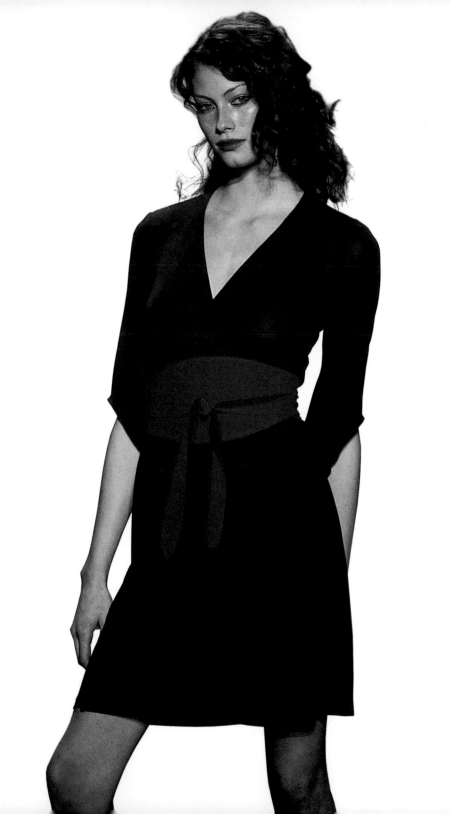

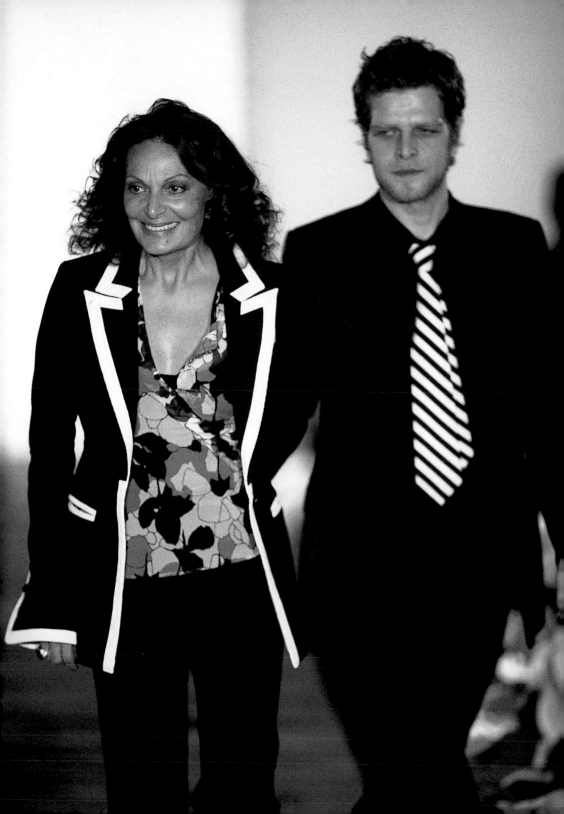

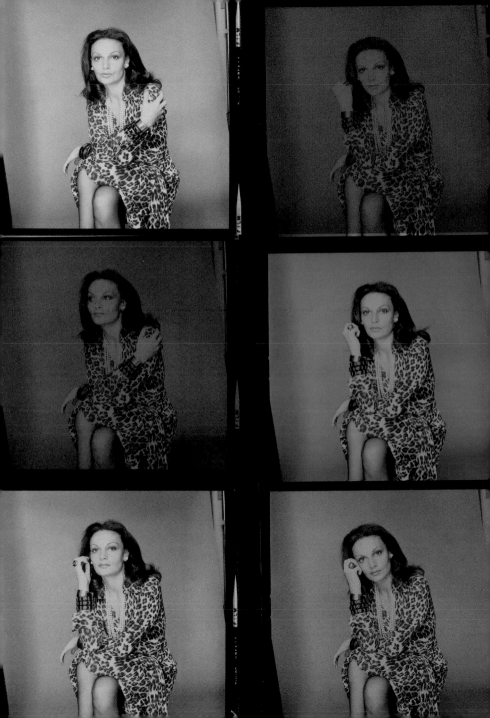

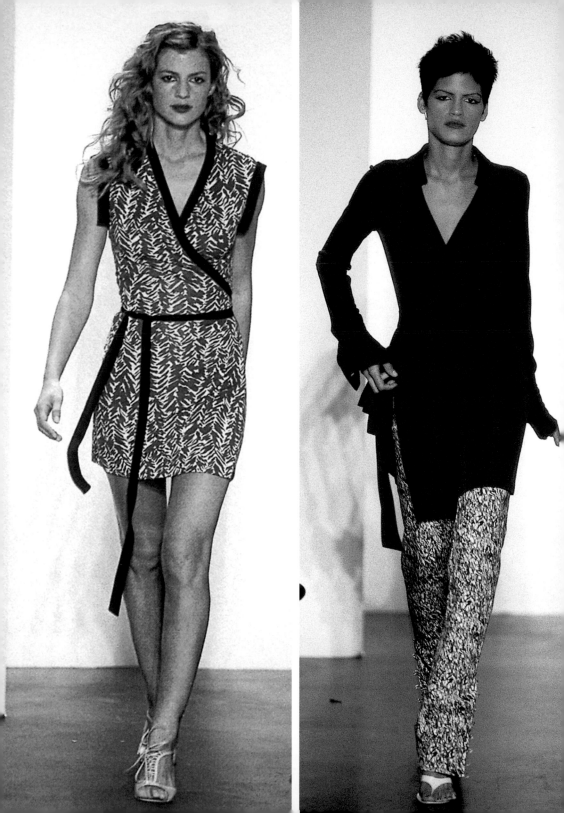

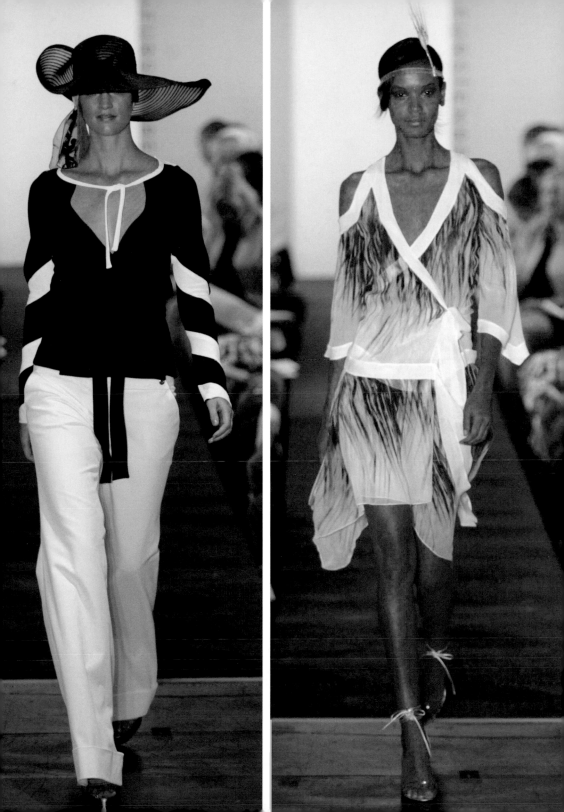

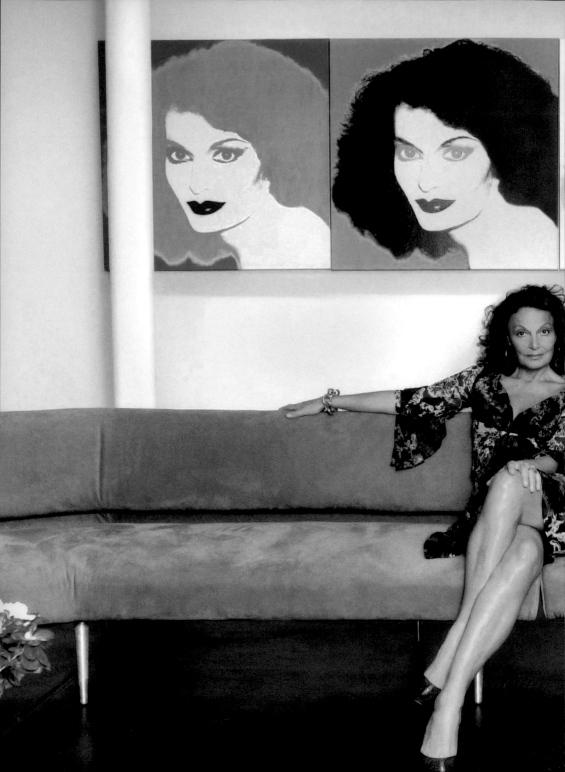

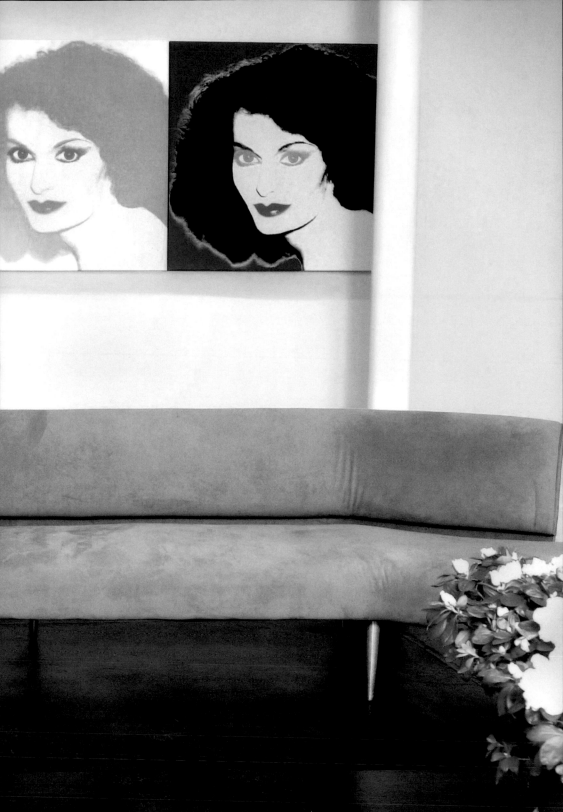

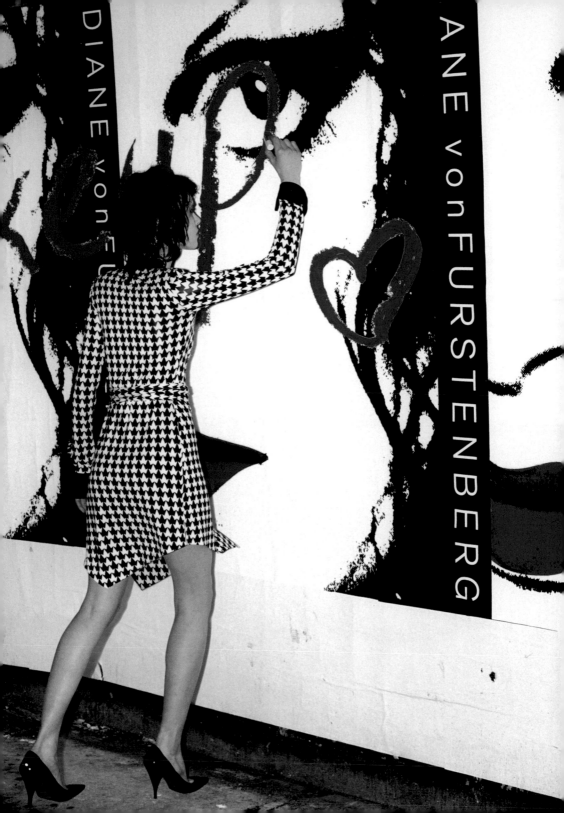

Chronology

1970: DVF walks into Diana Vreeland's office with her three dresses in a suitcase. Vreeland writes a letter to DVF congratulating her on her "smashing" designs, offering *Vogue*'s help.

1972: DVF responds to a void in American fashion by designing easy knit dresses, among them the "wrap dress."
While being photographed for her first advertisement, DVF writes "Feel like a woman, wear a dress" and signs a white cube she is sitting on. A signature is born.

1973: The wrap dresses make the cover of *WWD* with sketches of the snake and leopard prints.

1976: DVF sells 5 million wrap dresses and lands covers of *Newsweek* and *The Wall Street Journal*.
Opens Madison Avenue cosmetics shop and publishes *DVF's Book of Beauty*. The wrap dress is worn by celebrities, models, and feminists from Candice Bergen to Cheryl Tiegs to Gloria Steinem. Cybill Shepard wears a DVF wrap in Martin Scorsese's film *Taxi Driver*.

1983: Licensing her dress business, Diane moves to Paris to pursue a dream of writing and publishing books. She writes three lifestyle books: *The Bed*, *The Bath*, and *The Table*.

1989: Licensed DVF products sell over $1 billion in the 1980s.

1997: With the encouragement of her daughter-in-law Alexandra, Diane establishes DVF Studio, the new company headquarters, located in a 19th century carriage house on the edge of New York's meatpacking district. DVF returns to retail with the launch of the *Diane von Furstenberg* line of signature dresses.

1998: Actresses such as Gwyneth Paltrow are spotted wearing the wrap dress on the streets of NYC. Sarah Jessica Parker wears a vintage DVF wrap on *Sex & the City*.

2000: The *Diane von Furstenberg* collection continues to expand thanks to the overwhelming success of other lines, with the launch of a sportswear line.

The brand's initials. Illustration by Antonio Lopes, 1982.
© Antonio Lopes.

2001: Flagship boutique, Diane von Furstenberg the Shop, opens in New York's West Village. Nathan Jenden joins studio as Creative Director.

2002: Global distribution of Diane von Furstenberg collection expands.

2003: Diane von Furstenberg retail continues to expand with the opening of DVF the Shop Miami in Coral Gables, DVF the Shop London in Notting Hill, and DVF the e-shop at www.dvf.com.
DVF teams up with Venus Williams and Reebok to create a line of women's tennis wear. This is the first designer-infused line to appear on the women's professional tennis circuit, with Venus herself wearing the creations at Wimbledon and the US Open.
Diane von Furstenberg Beauty launches, including color cosmetics and a new fragrance, "D."

2004: Diane von Furstenberg opens her fourth free-standing store on the right bank.

Personal Board at work, with pictures of her loved ones.
© Courtesy of Diane von Furstenberg Studio.

Diane von Furstenberg

An encouragement letter that made all the difference, from the Empress of Fashion. Letter from Diana Vreeland, 1970. © Diane von Furstenberg Archives.
The American Dream: The 29-year-old Belgian girl who conquered America with a cotton jersey dress, on the March 22, 1976, worldwide cover of *Newsweek*. © 1976 Newsweek, Inc. All rights reserved. Reprinted by permission. Photograph by Francesco Scavullo.

My first advertisement, photographed by friend Roger Prigent: first dress, a shirtdress; first print, "links." "Feel like a woman, wear a dress," written rapidly on a white cube. © Robert Prigent, 1972.
Rerun: The same "links" print in a re-edition of the wrap dress. © Chris Coppola, 2002.

First windows at Lord & Taylor, New York. January 1974. © Photograph courtesy of Diane von Furstenberg Studio.

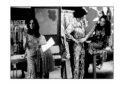

My first showroom at 530 7th Avenue. Real business has started, lots of Italian print jersey. © Photographs by Burt Glinn/Magnum Photos.

First recognition: *Women's Wear Daily* cover, "snake" print halter and two-piece dress. © Steven Stipelman, courtesy of *WWD*.
Cheryl Tiegs in a wrap two-piece pantsuit. © Bob Stone/*Vogue*, Condé Nast Publications Inc.

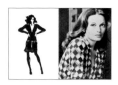

Illustration by Jon Matthews, 1987.
At work in a geometric print wrap dress. © Photograph courtesy of Diane von Furstenberg Studio.

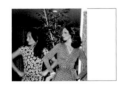

Flesh and fake: posing with a mannequin in Atlanta in 1977. © Photograph courtesy of Diane von Furstenberg Studio, 1977.

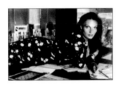

"Twig" print. © Courtesy of Diane von Furstenberg Studio.
Janice Dickinson in a black and white "zebra" dress. © Courtesy WWD.

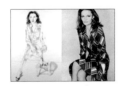

Designing woman: at work in 1977. © Ara Gallant, 1977.

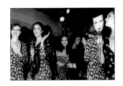

Behind the mask: Fall 1978 fashion show, styled by Michael Vollbracht. © Pierre Scherman, WWD.

On a stool. Portrait by Anh Duong. © Anh Duong, 2002.
On a stool in an early wrap dress. © Courtesy of Diane von Furstenberg Studio.

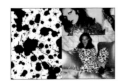

The original DVF print: Ink spots. © Courtesy of Diane von Furstenberg Studio.
Under the Warhols, Park Avenue, 1975. © Burt Glinn/Magnum Photos, 1976.

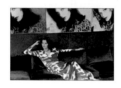

Back in fashion: Daniela Z. in a re-edition of the "twig" print wrap dress, photographed in Paris by Bettina Rheims in 1998. © Bettina Rheims, 1998.

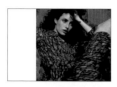

Lounging '70s: Long wrap dress in "seagull" print. © Pierre Scherman, *WWD*.

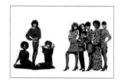

Liquid assets; Mix, sash, wrap.
Left: Iman, Gia, and Kelly, in 1982.
Right: Kelly, Isabella, Diane, Iman, Jacqueline.
© Courtesy of Diane von Furstenberg Studio, 1982.

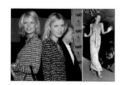

Icons of their time.
Left: The Hilton sisters in Diane von Furstenberg logo wrap dresses.
Right: Jerry Hall at a show at the Pierre Hotel in 1975.
© Courtesy *WWD*.

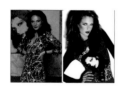

Iconography.
Left: A splatter-print wrap dress. © Burt Glinn/Magnum photo, 1977.
Right: A T-shirt in 2002. © Guy Ardoch, 2002.

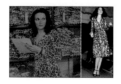

"Leopard" print craze.
Left: In the warehouse in 1977. © Courtesy of Diane von Furstenberg Studio, 1977.
Right: On the runway. © Courtesy *WWD*.

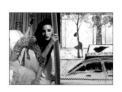

Going downtown.
Left: Re-launch of the wrap dress in 1998: Daniela Z. photographed in Paris by Bettina Rheims. © Bettina Rheims, 1998.
Right: In front of the studio. Illustration by Ruben Toledo for *Interview* magazine, September 2002. © Ruben Toledo, 2002.

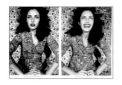

A thing of beauty is a joy forever: Daniela Z. photographed by Bettina Rheims for an advertising campaign promoting the re-launch of the wrap dress. "Serious/Laughing ad for DVF" © Bettina Rheims, May 1997.

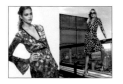

Urban inspiration.
Left: Crosstown Traffic Collection, "graffiti" print, urban way. © Dan Lecca, 2002.
Right: Urban "giraffe" print. © Feco Hamburger; MP Agencia de Fotografia, 2001.

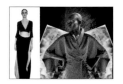

Japanese influence.
Left: "Geisha" long wrap. © Dan Lecca, 2002.
Right: "Kimono" wrap. © Roger Moenks & Laurent Alfieri, 2002.

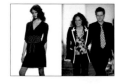

A new generation, a new vision.
Left: Geisha wrap, Japanese inspiration. © Dan Lecca, 2002.
Right: DVF with Creative Director Nathan Jenden. © Dan Lecca, 2002.

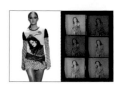

Pop Art is back.
Left: Crosstown Traffic Collection © Dan Lecca, 2002.
Right: Color is forever. © Courtesy of Diane von Furstenberg Studio.

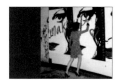

The wrap evolves..... © Dan Lecca, 2002.

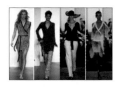

Serenity, maturity: Photographed in 2002 by Emmanuel Scorceletti in the studio, under the Warhols. © Emmanuel Scorceletti/GAMMA, 2002.

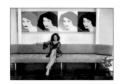

The wrap announces beauty: Renee Dorski photographed by Kenneth Cappello for a 2003 advertising campaign to launch the DVF beauty line. © Kenneth Capello, 2003.

Diane von Furstenberg would like to express her heartfelt gratitude to her friend André Leon Talley for writing this book. She would also like to thank Maureen Cahill, Jennifer Talbott, and all the artists and photographers: Guy Ardoch, Laurent Alfieri, Kenneth Capello, Anh Duong, Burt Glinn, Feco Hamburger, Dan Lecca, Jon Matthews, Roger Moenks, Roger Prigent, Bettina Rheims, Francesco Scavullo, Pierre Scherman, Emmanuel Scorceletti, Steven Stipelman, Ruben Toledo, and Andy Warhol, as well as all the models: Devon Aoki, Renee Dorski, Janice Dickinson, Jerry Hall, Paris Hilton, Nikki Hilton, Erin O'Connor, Cheryl Tiegs, Alek Wek, and Daniela Z. And, finally, Martine Assouline, for her golden touch.